I Spy Pinhole Eye

Philip Gross &
Simon Denison

Cinnamon Press
Independent Innovative International

Published by Cinnamon Press
Meirion House, Glan yr afon, Tanygrisiau, Blaenau Ffestiniog,
Gwynedd, LL41 3SU. www.cinnamonpress.com

The right of Philip Gross and Simon Denison to be identified as authors has been asserted by them in accordance with the Copyright, Designs and Patent Act, 1988. Copyright © 2009 Philip Gross & Simon Denison. ISBN: 978-1-905614-99-8 British Library Cataloguing in Publication Data. A CIP record for this book can be obtained from the British Library.

Designed and typeset in Palatino by Cinnamon Press. Cover design by Simon Denison © Simon Denison. Printed in Great Britain by the MPG Books Group, Bodmin and Kings Lynn.

Acknowledgments

Some of the poems have appeared previously in *New Welsh Review, Poetry London, Swansea Review*, and *The Rialto*.

The publisher acknowledges the financial assistance of the Welsh Books Council.

Contents

Foreword by George Szirtes

High tensile steel; L-section and T-section girders;
flat struts; twenty-four two-inch bolts, twenty-four
nuts, ditto, in four rows of six; heavy-duty poured
rough-moulded concrete; cement; gravel; water;
time; oxides of iron; undercoat rustproof ochre,
topcoat battleship grey; grey lichen; yellow lichen;
pennywort; spiderweb; sheep's wool; snail-slime;
(Materials)

> *...Believe*
> *me, this is what it says*
> *it is: and if it says nothing,*
> *being only steel and stone,*
> *why should we not believe*
> *it, tell me that?* (Via Negativa)

A poem is like a picture, said Horace in his *Ars Poetica*. If the first term is like the second term then, we assume the second is like the first. Our senses are not entirely distinct from each other. Qualities that appeal to the ear will appeal to the eye too. We could list them under broad abstract headings, in no particular order: aptness, grace, power, balance, lightness, daring, precision, intensity, scope... and so forth, arranged according to taste and magnitude.

The question is not whether the arts address common needs and desires in us, but how they address each other. The Greeks used the term *ekphrasis*, meaning literally 'speaking out' to denote the practice of speaking about visual art, something we all do, and are, generally, aware of doing inadequately. There, before you, is the visual work of art: first draw out that which it contains, then speak it. That is the *ekphrasis* programme.

The usual assumption in *ekphrasis* is a distinction between form and content.

The visual work, according to some, is to be 'read' like a system of codes or signs, like a book. One reads it by deconstructing it. That is to say, one reads it for what meaning, deliberately or inadvertently, it contains. A picture in such a case is *what* it depicts and *how* it depicts. The picture of a vase of flowers on a table depicts a vase of flowers and a table in a certain relation. The painting is not so much a solid naked object on which marks have been made, more an accumulation of significances. The materiality of the work, while not bypassed, becomes secondary except as metaphor, because materiality too is regarded as a container.

The shift is towards language and the dictionary. A thing is not only a thing: it is what it hides, and what it hides can be interpreted in terms of linguistics, psychoanalysis or ideology.

This is a rich and substantial process but it is a little one-sided. We may imagine the critic like Rembrandt's Dr Tulp holding forth on anatomy and mortality over the body of his half-dissected patient. The body is not entirely dissected: it retains character, is recognizable, is capable of bearing a personal name, but its parts add up to less than the whole and living figure of Dr Tulp. As depicted, that is.

In the case of the poet the process is rather different. The poet is engaged in a process comparable to that of the artist. The poet's negative capability, to employ Keats's term, is matched by the artist's own, perfectly proper: *dunno!* As the artist Mike Goldberg says to Frank O'Hara in O'Hara's poem, *Why I am Not a Painter*, when the poet notes that he has the word SARDINES in it:

> "Yes, it needed something there."
> "Oh." I go and the days go by
> and I drop in again. The painting
> is going on, and I go, and the days
> go by. I drop in. The painting is
> finished. "Where's SARDINES?"
> All that's left is just
> letters, "It was too much," Mike says.

The poet goes home to write reams and reams about the colour orange. Pretty soon,

he says, it is a whole page of words, not lines. Then another page.

> Pretty soon it is a
> whole page of words, not lines.
> Then another page. There should be
> so much more, not of orange, of
> words, of how terrible orange is
> and life…

This is not *ekphrasis,* not exactly, it is a mode of address: the way the poet addresses the realm of *orange* is the way the painter addresses *sardines*. Mike Goldberg ends up with a painting called Sardines, though the word 'sardines' has disappeared, O'Hara with twelve poems he calls Oranges, poems of how much and how terrible orange is, the 'terrible' meaning, I suspect, something like the Romantic Sublime, a term that will eventually disappear from the text, much like the word SARDINES has disappeared from Goldberg's painting.

 Photographers are not painters. Photographs have a different relationship to their subjects than the work of painters does to what they depict. It is a different mode of address. Nevertheless, they—like the painter, like the poet—address a world that is too much, that is terrible, the names of which are provisional and likely to disappear. Photographs have invited a whole literature of their own. "But O! photography, as no art is / Faithful and disappointing" wrote Philip Larkin. Faithful? Not necessarily, of course. Disappointing? No, not exactly that, though its manner of mediation is channelled through expectations of a detached objectivity that would seem to show us for what we actually are, not as we would wish to be. At a certain split second light has, after all, entered a dark chamber through a very narrow aperture and left a true, unmediated mark. A mark, at any rate, even if not precisely the mark we see on the paper, or on the screen, which has itself been mediated since, even if only so that we might look more as we wished to look. Nevertheless, a mark.

 Simon Denison has produced photographs of architecture, of quarry land, of city land, and of what he calls the human landscape, as well as of signs, wisps of

light and glimmers or sections of landscape that present us with feelings of mystery, loss, distance, alienation, and a kind of awe composed of all of these. Photographers, like painters, carry the history of photography with them, conduct its progress, so to speak, so the sense of a contemporary photograph is not exclusively its own moment: it is informed by a whole network of associations and memories.

Philip Gross is a meticulous and intensely thoughtful poet, so his responses to Denison's photographs, or, to be more precise, his assessment of the relationship between photographs and poems, is bound to be, and is, meticulous and thoughtful. It comprises not just a response to the photographs as images, but to the complex mixture of qualities in Denison's photography as well as the minutiae of the world picked out by Denison. The nature of photography, the "hush that comes upon us"; the aspect of the world the photograph has seized on, that "battered / shallow bowl of a world / with woods and wind"; the structures presented by the photographs, the "slender underpinnings" that "can support a span"; and all the associations that words conjure from a photographic image, from "surgical boot" and "calliper", to "hitman" and "million- / dollar-sweet metallic kit"; leaping from allusion to alliteration, from pylons walking "through the eye / of a pinhole" to the camera capturing "the kingdom of heaven": these, the structures and suspensions of language make concrete that which is only implied, not quite metaphor, in image. The linguistic imagination addresses the evidence before it not by defining it but by remaking it. The sensory, tactile aspect of the poem is the mind extending its fingers to grasp and touch the world through the film of language.

What Denison presents—the dark rootings of steel and concrete; the feeling of something slamming into the earth, establishing its narrow vocabulary of grass, stone, mould, leaf, strut, and the strange, focused moony chill that freezes everything—moves through the clarity, steadiness and humaneness of Philip Gross's verbal imagination to create something new. And that, after all, is the idea: the making new, the exploration, or apprehension of the way things are *too much* and *terrible*, as O'Hara saw, there always being something else under and beyond the changing names of things.

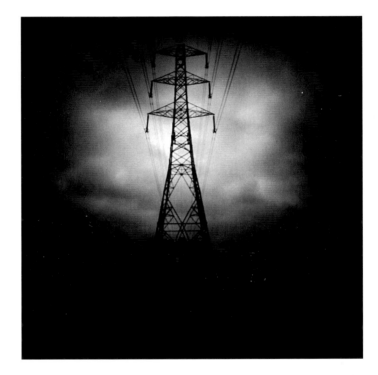

Nocturne for Pinhole Camera

An upstairs window lit.
A hollow in the night.

A five-watt sleeplessness.

An eye shut in its socket
fizzling with its worn nerves,

after-burn of one un-
remarked blink of the day,

and another, like bubbles

blown wobbling in above
the garden fence, from nowhere.
Falling, one singles you out
to print the concrete at your feet:

a wincing quick
wet kiss.

Seeing

Seeing only seeing

is the hush that comes upon us
in the camera obscura

round the battered
shallow bowl of a world

with woods and wind and
people seething in it.

Seeing them not seeing

we're the back row
of the silent picture palace,

the usherette's torch,
the zippo spark,

the cigarette tip glowing
here in Plato's cave.

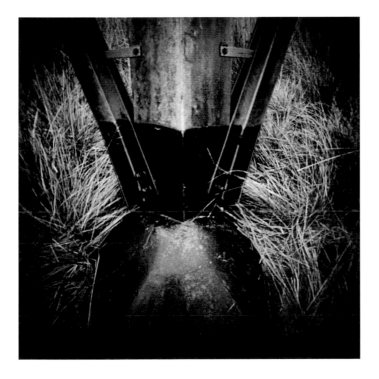

Hoard

These faint discs like coins of the realm
unearthed: rough chieftains with a face
they looted from the Romans, emblem
of a cursive horse, or in this case

the planted feet of pylons, meaning my
hillside my power my kingdom—blurred
at the edges, debatable, a find that might
be treasure trove, scene of the crime,

a miser's cache, a forger's hoard,
a trimmer's stash (cutting it fine
was a hanging offence), a shaft bored
into the rich seams of the world,
the common weal, into the grave-
vault. Mine, the robber cries, all mine.

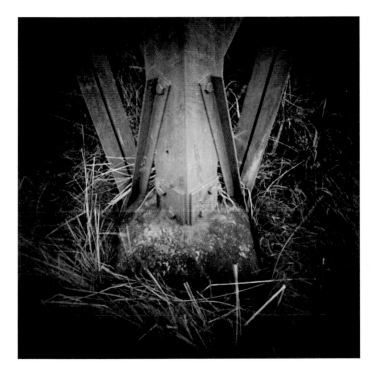

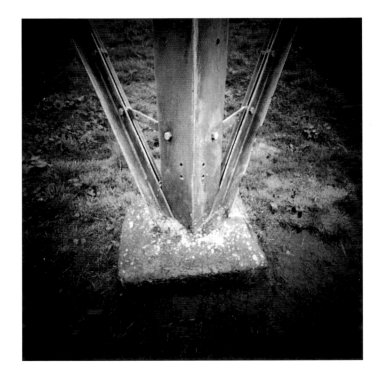

As the Man Said

Nice footwork, he said, staggered by the light
touch of girder on gradient. What if the rain

slews, soil shifts, the hills pitch and yaw?
A bit of engineering goes a long way

in a skewed world. Gravity—
the butt and thrust of it, the concrete

instances, how it drives its point home—
plays ball. We tread a fine line. Sheer

poetry, he said and kicked the pylon
fondly. You could hear its long hum-ding

right up the valley. The nimblest of moves
is to leave yourself standing. Like bloody

bally, as the man said, trying to find words
for grace that left him stumped, like us all.

Saccadia

Saccades: rapid tracking movements of the human eye,
unnoticed by the brain, between one fixed image and the next.

The people of Saccadia
are backroom boys.
See them crouched

to their exposures in the darkroom
plotting a map, or a plot
for an invasion, motionless

as Cortes, at each moment

on the brink

of breakthrough to another
world of which their one-
frame stories tell

like a whole new dimension.
Oh, to be in — no, to be
the movies…

Yggdrasil

In Norse mythology, the 'world tree', stretching between heaven and hell. The human world is in its lower branches.

Planted here (where else?), the world-
tree, its roots in a *boule* of concrete,
its planet of boulder, the split nut
from which it sprouted, its tendrils unfurled

to wires and hardened to girders while high
in its branches what roosts—what migratory
angels, decommissioned souls or,
with just enough charge in them to fly

off like swarf from a lathe, our under-
lived slivers of lives? *What, not dead?*
What now? they say, or less: a whicker

in the air, an overcast, like thunder
in the offing, close: a flickering
on the optic nerve, a pressure in the head.

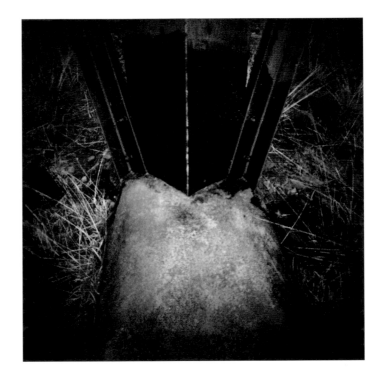

Cat's-eye

The shock of a world, caught

in a headlight beam.
A country road by night,

each weed brandished up towards you
fronds spread, as ruthless as beggars,

each branch like a meaning
overemphasised,

each particulate thing
crouched round at you, at bay:

the light from the retinal cave
the way a full moon throws it back

one moment when you don't know
which, you or the world,

will veer or break and run.

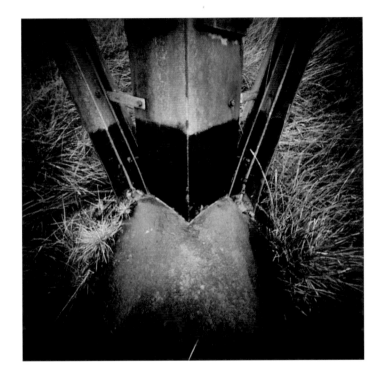

Long Exposure

No fast food for the eye,
this – no flash-in-the-pan, slapped
on the photographic plate
like paparazzi-pizza... but slow-
cooked in the black box half the day:
a concentrating taste, the spirit
of the place distilled, drip
by drip, like the portrait-painter's
brush, dip, dip, returns the sitter
to pure body, to still-life. Here
you could walk through the camera's
gaze and wave and gurn, and leave
not a trace of yourself on its
composure. Perhaps a slight smear.

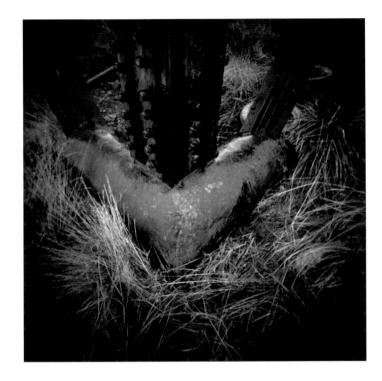

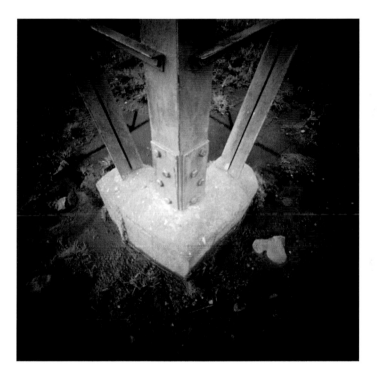

First Footing

I spy (the pinhole's eye) something
beginning. From a clod of concrete
planted like a colonist's first step
ashore. The founding father's. Or

first-footing, on the clean-swept
new year's doorstep: here's a man
blacked up with soot, sweep, dirt-
face, miner—a grin and an eye

that might spy what you can't
from inside in the warm. Poor
Crusoe, there's always a print

to mar your pristine beach. I spy
something: beginning is where
we wake up to the always-begun.

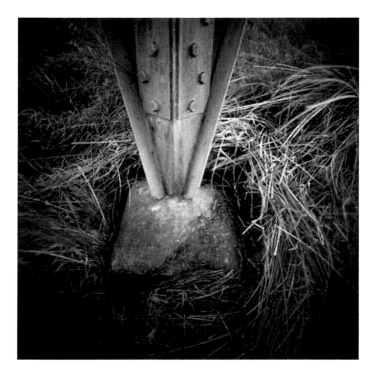

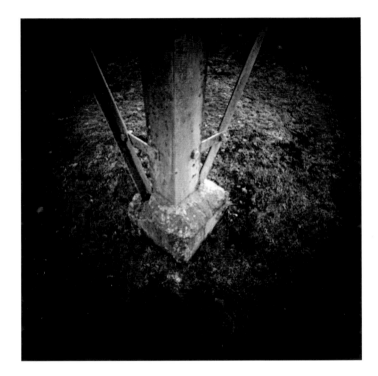

Bead

Fact, impacted
in a grainy dark

that sets it,
ingrows round its edges,

an antique silver frame
or the idea of silver,

tarnish like a brilliance
we might not care to face

and the bead might be little
or nothing—neutral

clearness—that picks up
this throwaway datum and that

and hangs it in the black
of space and is a world.

From Mars

So many vision seeds
fallen on stony ground…
but in this case, blink

and the planetary module, million-
dollar-sweet metallic kit,

wakes up to find itself
bedded down in a red grit desert

with a star-pocked rock, a bit
of rough. Think: if all of a world

could be that moment, pure dumb
found attention, unsoiled by the slightest

recollection of the long
fall through the night
before…

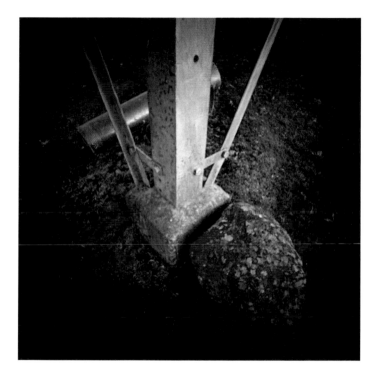

Writing This At 3 a.m.

In no-man's-time,
neither the day coming
nor the day before,

this is itself a pinhole:

night, the dark room,
no equipment
but the smallness

of the aperture.

One minute would do,
one second
better, or less,

if you could snap awake

in any instant
wholly, perfectly.

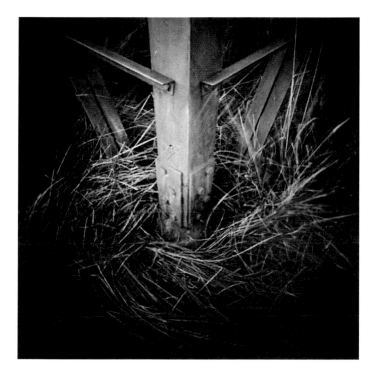

Slot

At the end
of the pier a-
ppears the peep
show we
the lower orders
hardly earn
our pennies for:

to see
not the sea
not the quay
but the key
hole—What
The godalmighty
Butler Saw.

Saccadia II

On the isles of Saccadia
no one in his right or any mind would think

to cross the sea of more-than-
dark between each wave-lashed blink—

the sea of nothing, whose tides rise,
flex and tighten round each, like
the iris round the pupil—so

their solemn *philosophes*,
the Saccadees, hold that we receive

each soul our moment, our retina-
branding flash-bulb dole of light,
and only in the album of a tourist god, are we

Saccadia: the archipelago.

Observing Angels

First, to narrow
your look
to a pinhead
then inch back

back (it's
a meditation
in itself)
back into the dark

of your own un-
seeing till
you get the focal

length, the
depth; the vision
clarifies.

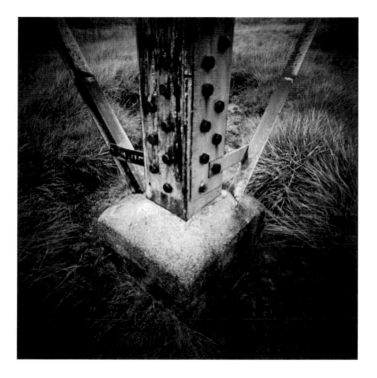

One Moment in the History of Pylons

Great whale of long migrations
(it seems not to mind that titchy
pod suckered up to its belly
like a parasite) the airship rides

at its mooring, dipping, heaving
gently (inside, shift and clink
of glasses on white linen), the grand
body led by the nose, like a prize

bull by a small boy: this pylon
that will not let go, even now
with the soft shock of that weight-

lessness becoming something lighter,
smooth shell peeling open: rearing
beats of new hatched flames like wings.

Any Old Pylon

 … which puts me in mind
of the day we were going to meet
beneath the greatest pylon of them all,

la tour Eiffel—those splayed girder feet

no protection as rain hissed and circling
traffic hissed back, an old record run
off the end of the song and can't eject.

Hum me that summer's Number One

and I'll fill in the words, in this
language or that, almost as if that day

had really happened, as if that *mise-
en-scène* wasn't everyone's and no one's

and always abroad. Besides, what use
would be a solitary pylon anyway?

Same-Psalm

On the uniqueness of the individual
there is plenty said, so let us sing

Same—the perseveration of pylons
shuffling to likeness on their clod-bound feet

whatever the slope. Each quirk of a bolt
here, there an extra bracing, is a symptom,

scar or affectation—in short, personality.

Like the knee-doctor who makes conversation
(gravely smiling) with this lesion, that dwindling

bone density, or the therapist or the priest
nodding to the same old hungers, two or three

same shames, same bruises, we come to the wood
of common being through the trees of detail

case by case by case by case.

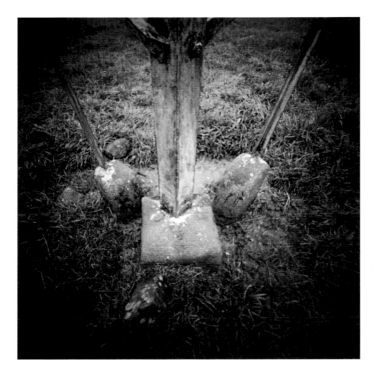

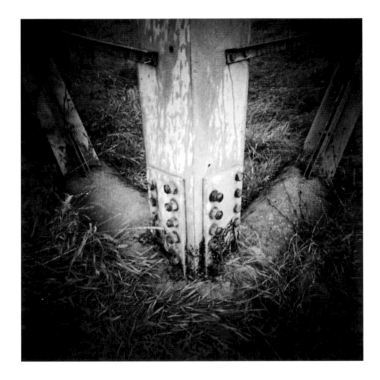

Materials

high tensile steel L-section and T-section girders
flat struts twenty-four two-inch bolts twenty-four
nuts ditto in four rows of six heavy duty poured
rough-moulded concrete cement gravel water
time oxides of iron undercoat rustproof ochre
topcoat battleship grey grey lichen yellow lichen
pennywort spiderweb sheep's wool snail-slime
meadow-grass in clumps moss loose stones
bird droppings rabbit droppings urine sheep and fox
wind rain black box photographic paper God's
impartial sunlight time stamps padded envelope
black fibre-tip (0.5mm) A4 folded to A5 time lap-
top plastic socket 4,500 miles of the National Grid
substation power station many pylons maybe this

Constitutional

Grey-violet blueberry slobber,
bird-splats in the gorging season

where they perch in session
on this comfortably limed

rock-Parliament or high Bench
in their various robes of birdhood

handing fertiliser down:

The pylon itself is one among
and over them, weighing the wires

of justice in each hand, such
gravitas, who would dare mention

on its collar, a stain, a ripe spit-
dribble at the corner of its mouth,

a drop of port that got away?

Monsieur le Blackbox

stands for an hour in a field, affecting
innocence—
 neither quite so innocent
nor so affecting as he'd like to think:

the time, for a start, it takes to fix
one image, he takes it, but from where,
from whom? There must be less for us.

And the daylight? He siphons it in.
Insatiable, his makeshift apparatus—

cardboard box, time, a narrow intent
and you can build a black hole, take it
anywhere without a permit. Would you want
him in your back yard? *I am like the lilies
of the field*, he says. *I photosynthesise.*

He ought to get a job. He owes a lot of rent.

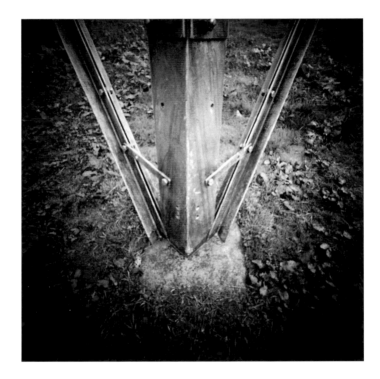

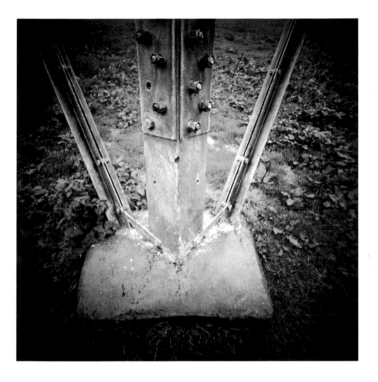

Bathysphere

The pressure of the world they're winched
down into: just doubleglazed inches away

a manifest silence, like a slow continual blow,
a car crash impact from all sides at once.

Near freezing, they sweat in their shorts,
Messrs Barton and Beebe and their quickening

breathing as the bathysphere, ironclad
eyeball, with one porthole and a blunted

headlight beam pries into an unknowing
thick as silt.
 And if beings of clearness

and light were lowered down amongst us
wouldn't they gasp at the first grey glimpse

of rubble like a landfall, and wouldn't they flinch
and goggle should some grey-on-grey shape move?

Saccadia III

The chronicles of Saccadia are written
in the present tense. On individual pages.

They are read in public once a year
by everyone, in concert, one sheet each

and the cacophony, so close
to white noise, is their near-communion

with the Oneness—Which, dispersed
into atoms, might, might just remember...

... but secretly, who hasn't had that dream,
that heresy: the great explosion, time
erupting on the updraught high above

the burning library, words like ash, in-
terrogated, deconstructed by the once-
for-all praxis of flame?

Pylon In The Mist

Forget these club-foot underpinnings.
My mind's somewhere higher. Can you follow

me up to where I strip down to geometry?
To where the proof of a theorem must be true

because elegant. Not a nut or bolt for show,
but each pleat and dart of the stress field

traced on the mist in rust-painted steel,
like an intellectual necessity. Essential

me, out in all weathers wearing nothing
but my purpose—as ascetic, ideal

and myself as a bare tree in winter. Possessed
by a certain charisma—can you hear it,

power, everywhere and nowhere, its dry
crackling in the cloud around my head?

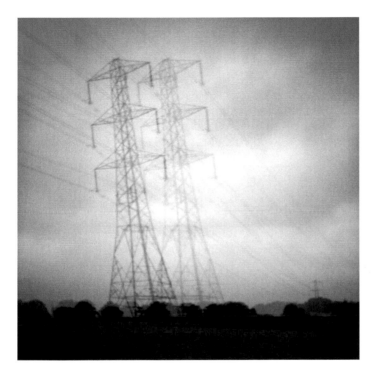

Stoneground

A well-baked loaf of granite, whole-
some, full of grit and grain
and a difficult goodness, cold
to touch, glazed with rain—

a foursquare meal, foundation
of a healthy constitution, a regime
of steel-limbed callisthenics, bracing
mass-athletics, a dictator's dream

becoming nightmare: pylons *will* resemble chain-
gangs, skeletons in frill and furbelow,
their voices wind-racked vowels, *A-e-o-*
lian harps that play from no score their control-
lers can control. (The boss wakes in a sweat.
Shoot the chef. Must be something he ate.)

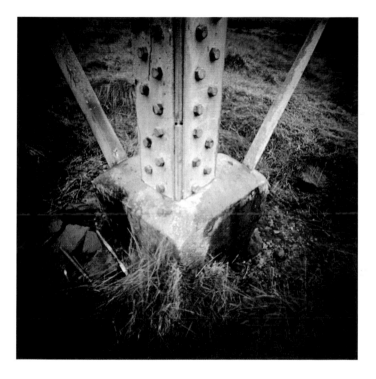

Pax Pylonica

Power goes where it's called for—takes
hills in its stride, as straight as Roman
syntax. There's no place we're not
overlooked, no skyline not garrisoned.

If not for them, we'd be deep
in the dark ages here, our sulking
valleys, history. We stay in,
nights, and watch the world perform

on the television *they* make hum.
Would you want one in your garden?
Here, sign this. (Now and then again

they'll fail us and we'll rise up
powerless and indignant—kids
left with the run of the house, forlorn.)

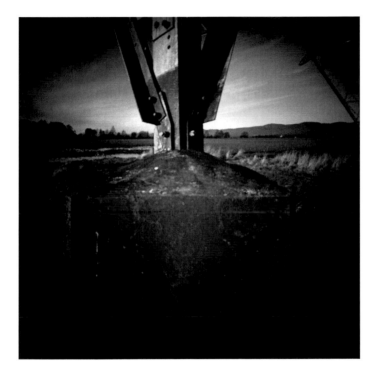

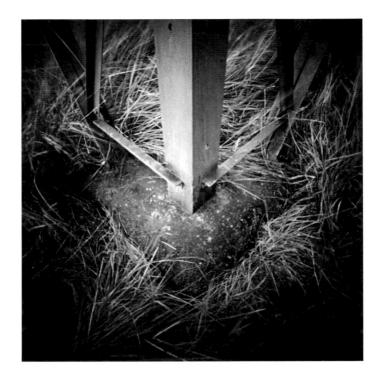

Underpinning

It might look like a cast
concrete heart but the one
true and pertinent question
is that of vertical thrust: what
in tonnes per square centimetre
drag and windspeed—while assuming
the surveyor's levelling up of the meaning
of true—trusting the set of eye and instrument
so the notional point at which the world and all
its forces intersect in the core of the block might not
within our range of tolerances and not accounting for
acts of God *shear* suddenly or crumble grain by grain but
still *consist* for at least an actuarially determined lifetime which
is the best any one of us dare wish ourselves and those we love.

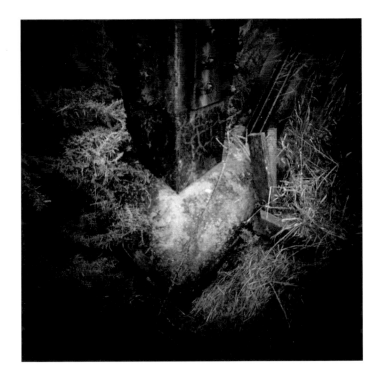

Paint Chart

squid ink tired lavender dust of purple
half-an-hour-before-dawn ringdove grey

custard-powder-pink edging to yellow
dilute-to-taste unsweetened lemon moon

limestone old grist donkey in the drizzle
white with a hint of black black black

handled mahogany sweat of several races
white with a hint of almost cimmaroon

as if the world was not enough already
eau de mould betel spit milky dribble
by the names we pick and mix *we choose*

bilberry lips tobacco teeth spilled-tea-
on-the-duvet random viridian ripe birthmark
smeared lipstick last Saturday night's bruise

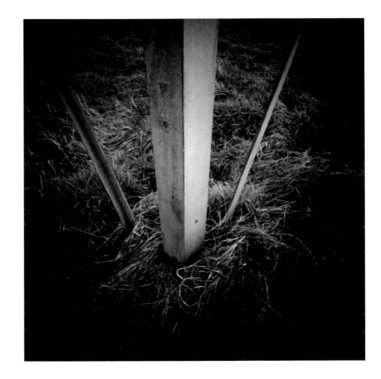

Believing

That seeing and believing
are a structure, cross-struts of each other...
How such slender underpinnings

can support a span... Let us consider

girders: say belief is the vertical
out of our ken, cross-braced
by slim physical evidence

or conversely that it is sense

stretches off away to smallness
that's much like immensity, and only
the story that we hold

ourselves to be in holds us
upright
pulsing slightly in the wind

Via Negativa

 This is not,
say, a surgical boot or a calliper,
not a clog or mud-clagged wellie,
not the footgear fitted by the hitman
as he sends you down to stand
bolt upright in the dock silt, rocking
in the current on your concrete
plinth, a Subbuteo man…

Need I go on? Believe
me, this is what it says
it is, and if it says nothing,
being only steel and stone,
why should we not believe
it, tell me that?

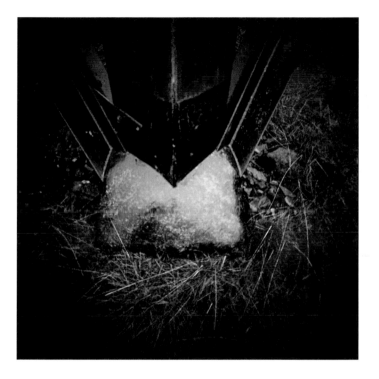

The Twentieth Century

How many hours in the sealed truck night or day,
how many miles north or east, how many degrees
below… Even if any other body there could say

in any other's language, it would have been drowned
by steel on steel. His one thought left was: Find a way
to *see* (rasping a tin spoon's broken handle round,

round in damp wood—blisters, blood—punching through
a spyhole just as the train winced to a halt.) The sound
of stillness was the tinnitus of steam. His eye pressed to

the hole, he made out greyish girders in the dim light:
maybe a crane? a bridge? And this is all he ever knew.
Maybe a dockside, a guard tower, a construction site?

A life sentence of labour… or a radio telescope array
to scan impartial stars, beyond our day, our night…

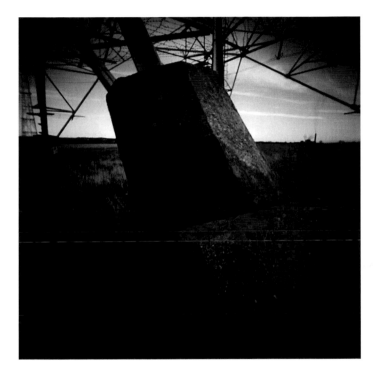

POETRY LIBRARY

Parable

It is easier
for a pylon to walk
through the eye
of a pinhole

than for a man
with a camera
to capture the kingdom
of heaven

or for a man
with a sonnet
to trust to the light
and say unto you
Yea
verily.

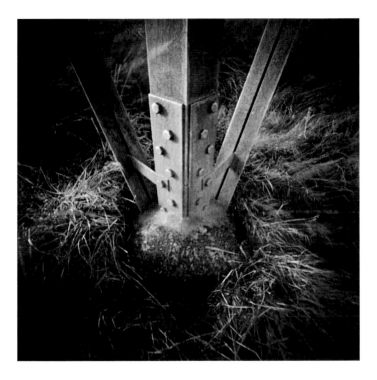

Listening In

1

Up here on the surface of things
 we're in everyday
wavelengths—wind
 through the pelt of the hillside
making it bridle and hiss;
 the fidgeting of stray
watts and volts round the powerline.
 But inside,
an inch remote,
 beneath the skin of steel…?
Eavesdroppers, snoops,
 we hold a microphone
to its biscuity battleship paint;
 half hear, half feel
the audible stress patterns
 in the girder's bone,
a chink and ping like sonar:
 something gone
as soon as glimpsed
 somewhere between the ear
and the equipment,

 in the tinnitus brought on
by trying.
 So we up the volume, peer
into the silt
 of listening. So its own
hiss rises. So
 we disappear.

2

Deaf, but nothing like silence.
 My father's down
in the lowest ranges.
 He's slipped under
the surface of hearing
 to a boom of ground-
bass, lightning crackle,
 random thunder.
The edges of words
 have gone, most consonants.
Instead, sullen percussions
 and slurred
voices off,

all unrelated incidents,
too much, too little,
over-/under-heard
like a mobile left on in the pocket
thuds
and whickers,
like a microphone in wind
or breath,
as a crackle of radio noise from space
is the end of a story,
the fingerprint smudge
of a galaxy folding itself away
and in
to silence, maybe.
That would be a grace.

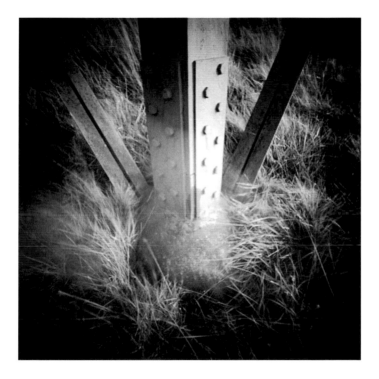

Sonnet, Interrupted

A heat wave, peak TV at teatime and a blown
fuse: that's all it takes. Rolling overload.
Cities fold their lights up zone by zone,
the signals seize, road crunches into road,
fridge freezers shudder and die; soon meat blood
will be leaking. (Should we not have known?)
The pylons look on, shrug by shrug by shrug…

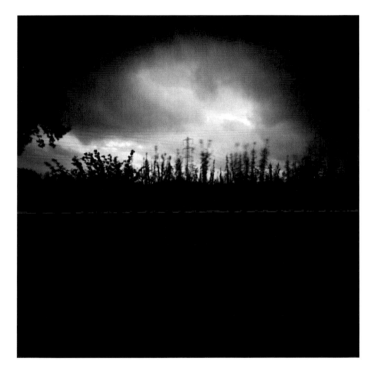

Picture this:

an organism hungry for the moment—one

whose membranes peel themselves precisely
as an f-stop or a rose

with appetite,
a buttery globe artichoke,

down and in to the *ah!* for the one sense
it possesses—sight—

its light-sensitive heart
one exposure that fixes the world

like whatever a goose chick's egg
of dark cracks open onto (*mother mother.*)

It withers as quick as a puffball,
as disposable as mated damselflies

while spores blow like pure hunger
unsuspected through our lives

and round the planet knowing
each time one thing more

until nothing anywhere has not been seen.
Now picture that:

God

satisfied.

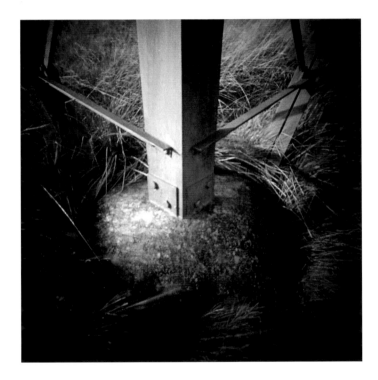

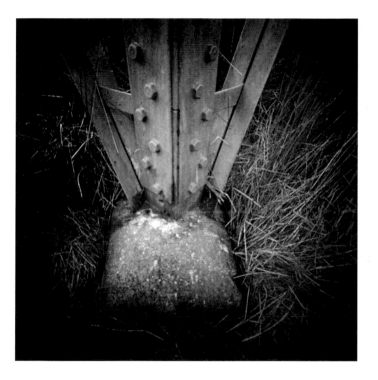

Endnotes

Why the feet of pylons? Many would regard them as a profoundly odd photographic subject. Pylons are the pariahs of the landscape, excluded from every postcard view, detested as eyesores, it seems, by most people who bother to think about them at all. Who would even consider looking at their feet? Yet photographers have long sought to play the alchemist, to turn dross into gold, to make pictures where few (or none) have been made before. Photographs describe, but they also elevate and transform; that's their beauty. They tell part of the truth, never the whole of it; that's their secret.

This series began on the spur of the moment. I had the camera, passed a pylon, and thought, what if? But it proceeded with a certain method: that of minimising, as far as possible, my own role as decision-maker. The camera—a homemade box made of mountboard, duck-taped to a 6x6cm film back, with a pinhole drilled in the front, and a piece of black tape for a shutter—contains no lens, no viewfinder, no technology except for the film itself. It was positioned at the same distance (an arm's length) from each foot of every pylon I came across, until I had had enough. I made no selections in the field, and I never knew what the camera had seen until the negatives were scanned. It was different every time; and never what I expected to see.

I invited Philip to respond to the pictures in order to tease out some of their suggestive possibilities. Just as the photographs are not exactly *about* pylons, or their feet, nor too are the poems (how different, then, from the 'pylon poetry' of the 1930s that celebrated pylons as symbols of progress). Those feet were only the beginning.

Simon Denison

So, these poems… what are they *about*? About the pylons, or about the photographs? About the way the camera, or the brain, 'sees'… or about the word itself, that mysterious 'about'?

In the 20th century, paintings came to be less 'of' things (cameras, it seemed, would take care of that) than 'about' them—discussing, exploring, exploding them even. (Photography, of course, turned out to be far more than a factual visual record, too.)

Meeting Simon's pinhole images, their meditative single-mindedness, (there are far, far more of them than printed here) I found myself thinking not just of them, but around, about. Like the Zen *koan*, which teases the mind into fractals of logic, cracklings of association, sheer rapt pleasure at the variousness of simple things, they are a question which calmly sits and asks 'And then? And… *then?'*

If Simon's method walks a straight line across a wide field, the poems do what a dog does, off its leash. They run off at all angles, in wild circles, coming back panting to their human's feet. They do return. (In art, limitation makes for liberation.) What holds them is allegiance to the common thing, the walk together… that, and the number fourteen. (Yes, even the two exceptions are a half and a one-and-a-half of that measure.) Are they sonnets? Any fourteen-line poem alludes to the sonnet… and *allude* is what these do—with a stress on the *–lude*. They play. How far can we run from the sonnet and still come panting back? They are about the sonnet as they are about photography, or power, or perception, or God.

They are also an invitation to the reader/viewer. From the simplest stimulus, ripples spread out, out, about. *Keep looking*, say the poems. *There's more. We are not the last word.*

Philip Gross

Philip Gross is an award winning poet, fiction writer, dramatist and Professor of Creative Writing at Glamorgan University. Previous poetry collections have been Recommendation, Special Commendation or Choice of the Poetry Book Society, whilst *The Wasting Game* was also shortlisted for the Whitbread Prize. Of his twelve poetry collections, two have been limited editions including wood engravings and artist illustrations. Other projects have been collaborations with painters, sculptors, dancers and musicians. For further information, see: www.philipgross.co.uk

Simon Denison's documentary and conceptual landscape photography has been exhibited nationally and internationally. He is the author of two previous photographic books, *The Human Landscape* (2002) and *Quarry Land* (2005) and his work has been reviewed widely including in *The Times*, *The Guardian* and on BBC Radio 4. He is a lecturer in the history of photography at Birmingham City University's Institute of Art and Design, and he writes regularly for the photography journal *Source*. For further information, see: www.simondenison.co.uk

George Szirtes is a leading poet, critic and translator, whose many awards include the TS Eliot Prize in 2005. A Fellow of the Royal Society of Literature, he trained as a painter, has a lifelong concern with the relationship between poetry and visual art and is the author of *Exercise of Power: the Art of Ana Maria Pacheco* (2001). He set up the MA in Writing the Visual at Norwich School of Art and Design. He is married to the painter Clarissa Upchurch, and their collaboration *Budapest: Image, Poem, Film* was published in 2006.

Additional artwork from *I Spy Pinhole Eye*, including photographs, video artwork and poetry readings, can be found online at www.simondenison.co.uk/ispy.html